O to seek relief . . . and write a few words carelessly.

Virginia Woolf (1882–1941)
English writer

Canadian representatives: General Publishing Co., Ltd.,
30 Lesmill Road, Don Mills, Ontario M3B 2T6.

9 8 7 6 5 4 3 2 1
Digit on the right indicates the number of this printing.

ISBN 1–56138–558–1

Cover illustrations by Jody Winger
Cover design by Jung-Hyun Yoon
Interior illustrations by Susan Todd
Interior design by Susan E. Van Horn
Edited by Brian Perrin
Typography: Mona Lisa by Deborah Lugar
Printed in the United States

This book may be ordered by mail from the publisher.
Please add $2.50 for postage and handling.
But try your bookstore first!

Running Press Book Publishers
125 South Twenty-second Street
Philadelphia, Pennsylvania 19103–4399

THE ART OF WRITING

An Illustrated Journal

RUNNING PRESS
PHILADELPHIA · LONDON

Writing is not, for us, an art, but breathing.

Anaïs Nin (1903–1977)
French-born American writer

If you wish to be a writer, write.

Epictetus (c. 60–110)
Greek philosopher

I write because I am curious. I am curious about me.

Pat Mora (b. 1942)
American poet and writer

Most writers write to say something about other people—and it doesn't last. Good writers write to find out about themselves—and it lasts forever.

Gloria Steinem (b. 1934)
American activist, editor, and writer

[I write] for my own reasons, not for literary reasons.

Amy Tan (b. 1952)
American writer

W riting was the soul of everything else. . . .
Wanting to be a writer was wanting to be a person.

Patricia Hampl (b. 1946)
American writer

The impulse to write things down is a peculiarly compulsive one, inexplicable to those who do not share it, useful only accidentally, only secondarily, in the way that any compulsion tries to justify itself.

Joan Didion (b. 1934)
American writer

One tends to write out of obsession. . . .

William Trevor (b. 1928)
Irish educator and writer

I wrote from the time I was four. It was my way of screaming and yelling, the primal scream. I wrote like a junkie. I had to have my daily fix.

M. F. K. Fisher (1908–1992)
American writer

I always wanted to become a writer, a real, published writer—the way other girls at school wanted to become actresses.

Mary Stolz (b. 1920)
American writer

My father used to give me a nickel for every story I wrote, and my mother wove strips of construction paper together and stapled them into book covers. So at an early age I felt myself to be a published author earning substantial royalties.

Louise Erdrich (b. 1954)
American writer

I come from the tradition of storytellers, and that tradition is thousands of years old; but I'm different from the others in that I write, whereas the rest of them used memory and the moods of the audience.

Maxine Hong Kingston (b. 1940)
American writer

I always enjoyed telling other people
the exciting things I had learned about
the living world, and folks often told me
I explained things so well I should
become a writer.

Dorothy Hinshaw Patent (b. 1940)
American educator and writer

Writing, I think, is not apart from living. Writing is a kind of double living. The writer experiences everything twice. Once in reality and once in that mirror which waits always before or behind.

Catherine Drinker Bowen (1897–1973)
American writer

I think it is very important for a writer to write what he doesn't know. . . .
I find it facile at times to write about what you know. But writing about what
you don't know is wonderful adventure. It plunges you into realities,
invisibilities, that you hardly suspect.

Carlos Fuentes (b. 1928)
Mexican writer

When I've taught [writing] classes, I always say, "Forget about 'Write about what you know.' Write about what you don't know." The point is that the self is limiting. . . . When you write about what you don't know, this means you begin to think about the world at large. You begin to think beyond the home-thoughts. You enter dream and imagination.

Cynthia Ozick (b. 1928)
American writer

When one wants to write, one must see
everything, know everything, laugh
at everything.

George Sand [Amandine A. L. Dupin] (1804–1876)
French writer

There is only one trait that marks the
writer. He is always watching. It's a
kind of trick of the mind and
he is born with it.

Morley Callaghan (b. 1903)
Canadian writer

Long before I wrote stories, I listened for stories.

Eudora Welty (b. 1909)
American writer

A student asked, "Do you think I could be a writer?" "Well," the writer said, "I don't know. . . . Do you like sentences?" If he had liked sentences, of course, he could begin, like a joyful painter I knew. I asked him how he came to be a painter. He said, "I liked the smell of the paint."

Annie Dillard (b. 1945)
American writer

I loved words. . . . I loved their sounds and rhythms.

Eloise Greenfield (b. 1929)
American writer

The only certainty about writing and trying to be a writer is that it has to be done, not dreamed of or planned and never written, or talked about (the ego eventually falls apart like a soaked sponge), but simply written: it's a dreadful, awful fact that writing is like any other work.

Janet Frame [Clutha] (b. 1924)
New Zealand writer

It's easy, after all, not to be a writer.
Most people aren't writers, and very
little harm comes to them.

Julian Barnes [Dan Kavanagh] (b. 1946)
English writer

No one is born with any kind of "talent" and, therefore, every skill has to be acquired. Writers are <u>made</u>, not born. To be exact, writers are self-made.

Ayn Rand (1905–1982)
Russian-born American social critic and writer

Talent is nothing but long patience.

Gustave Flaubert (1821–1880)
French writer

Write every day. Every single day.

Jessica Mitford (b. 1917)
English writer

I can never understand why people who have not seen me for a while ask if I am still writing. They might as well ask if I am still breathing.

Phyllis Reynolds Naylor (b. 1933)
American writer

Looking back. I imagine I was always writing. Twaddle it was too. But better far write twaddle or anything, anything, than nothing at all.

Katherine Mansfield (1888–1923)
New Zealand-born English writer

[Writing is] a matter of exercise. If you work out and lift weights for fifteen minutes a day over a course of ten years, you're gonna get muscles. If you write for an hour and a half a day for ten years, you're gonna turn into a good writer.

Stephen King (b. 1947)
American writer

Like the New England soil, my talent is good only whilst I work it. If I cease to task myself, I have no thoughts. This is a poor sterile Yankeeism. What I admire and love is the generous and spontaneous soil which flowers and fruits at all seasons.

Ralph Waldo Emerson (1803–1882)
American poet and writer

I write when the spirit moves and I make sure it moves every day.

William Faulkner (1897–1962)
American writer

I write all day: I don't have lunch out. If you work everyday, at the end of the year you have [a] book.

Mary Higgins Clark (b. 1929)
American writer

Writing is harder than anything else; at least <u>starting</u> to write is. It's much easier to wash dishes. When I'm writing I set myself a daily quota of pages, but nine times out of ten I'm doing those pages at four o'clock in the afternoon because I've done everything else first. . . . But once I get flowing with it, I wonder what took me so long.

Kristin Hunter (b. 1931)
American writer

If I waited for perfection . . . I would never write a word.

Margaret Atwood (b. 1939)
Canadian writer

Talent is helpful in writing, but guts are absolutely necessary. Without the guts to try, the talent may never be discovered. . . .

Jessamyn West (1907–1984)
American writer

There are two weapons in the writer's arsenal. . . . The first is stamina and the second is uncompromising belief in yourself.

Leon Uris (b. 1924)
American writer

... it takes one's whole life to conceive
a book and a few weeks or months, or
possibly years, to write it.

Mary Stolz (b. 1920)
American writer

It has taken me years of struggle, hard work and research to learn to make one simple gesture, and I know enough about writing to realize that it would take as many years of concentrated effort to write one simple, beautiful sentence.

Isadora Duncan (1878–1927)
American dancer

Masterpieces are not single and solitary births; they are the outcome of many years of thinking in common.

Virginia Woolf (1882–1941)
English writer

I learned that you should feel when writing, not like Lord Byron on a mountain top, but like a child stringing beads in kindergarten—happy, absorbed and quietly putting one bead on after another.

Brenda Ueland (1891–1985)
American educator and writer

At its best, the sensation of writing is that of any unmerited grace. It is handed to you, but only if you look for it. You search, you break your heart, your back, your brain, and then—and only then—it is handed to you.

Annie Dillard (b. 1945)
American writer

When God hands you a gift, he also hands you a whip; and the whip is intended for self-flagellation solely.

Truman Capote (1924–1984)
American writer

I don't enjoy writing, and I certainly would not do it for a living. Some people do, but some people enjoy flagellation.

Prince Philip, Duke of Edinburgh (b. 1922)

Writing a book is a horrible, exhausting struggle, like a long bout of some painful illness. One would never undertake such a thing if one were not driven on by some demon whom one can neither resist nor understand.

George Orwell [Eric Blair] (1903–1950)
English writer

It was so hard to sell a story that I barely made enough to eat. But I knew I wanted to write. I had dreamed about it for years. I wasn't going to be one of those people who die wondering, <u>What if</u>? I would keep putting my dream to the test—even though it meant living with uncertainty and fear of failure. This is the Shadowland of hope, and anyone with a dream must learn to live there.

Alex Haley (1921–1992)
American writer

Let's face it, writing is hell.

William Styron (b. 1925)
American writer

Writing is the most demanding of all callings, more harrowing than a warrior's, more lonely than a whaling captain's—that, in essence, is the modern writer's message.

Melvin Maddocks
Contemporary American writer

Writing's not terrible, it's wonderful. I keep my own hours, do what I please. When I want to travel, I can. But mainly I'm doing what I most wanted to do all my life. I'm not into the agonies of creation.

Raymond Carver (b. 1938)
American writer

Writing as a career is a good life and a rewarding one. It represents
a continuing challenge. Each writing project is like a difficult battle: requiring
a skilled combination of strategy and tactics to accomplish a specific objective.
It demands a mobilization of concentration—and concentration is or should be
one of the higher gifts of human mental activity.

Norman Cousins (1912–1990)
American writer

This work is a torture on the rump but a joy to the heart.

Eduardo Galeano (b. 1940)
Uruguayan historian and writer

Writing is really a pleasure that I seek out actively. . . . I have a special area where I live where I do my writing. I sit down and things start coming.

Laurence Yep (b. 1948)
American writer

I type in one place, but I write all over the house.

Toni Morrison (b. 1931)
American writer

I write at the far corner of counters . . . on a stool at all-night coffee shops in the San Fernando Valley. Just some white paper and the land inside my head.

William F. Nolan (b. 1928)
American writer

The ideal view for daily writing, hour on hour, is the blank brick wall of a cold-storage warehouse. Failing this, a stretch of sky will do, cloudless if possible.

Edna Ferber (1887–1968)
American writer

Every time I sit at my desk, I look
at my dictionary, a Webster's Second
Unabridged with nine million words in
it, and think: All the words I need are
in there; they're just in the wrong order.

Fran Lebowitz (b. 1951)
American writer

Writing is easy. All you have to do is cross out the wrong words.

Mark Twain (1835–1910)
American writer

Easy reading is damned hard writing.

Nathaniel West (1903–1940)
American writer

Remember: good books are not written:
they are rewritten.

Phyllis Whitney (b. 1903)
American writer

Writing is like roses: the harder you prune it, the better it blooms.

Rhona Martin (b. 1922)
American writer

It is a struggle when I have to cut. . . . I also enjoy cutting. . . . Writing is not like painting where you add. It is not what you put on the canvas that the reader sees. Writing is more like a sculpture where you remove, you eliminate in order to make the work visible. Even those pages you remove somehow remain.

Eli Wiesel (b. 1928)
Romanian-born American writer

A spendthrift story has a strange way of seeming bigger than the sum of its parts; it is stuffed full; it gives a sense of possessing further information that could be divulged if called for. Even the sparest in style implies a torrent of additional details barely suppressed, bursting through the seams.

Anne Tyler (b. 1941)
American writer

Only the hand that erases can write
the true thing.

Meister Eckhart (c. 1260–1327)
German theologian and mystic

A piece of writing must be viewed as
a constantly evolving organism.

H. L. Mencken (1880–1956)
American journalist

When the sentence finally works out it clicks into place shining a ray of clarity into the confusion with which you've been struggling. A clear sentence is a moral. As a writer I don't want to be remembered or noticed for the story I thought up or the information I presented. I want to be remembered for how I said it.

John Jerome (b. 1932)
American writer

The use of words is . . . an interesting study. You will hardly believe the difference the use of one word rather than another will make until you begin to hunt for a word with just the right shade of meaning, just the right color for the picture you are painting with words. Had you thought that words have color? The only stupid thing about words is the spelling of them.

Laura Ingalls Wilder (1867–1957)
American writer

The moon, like a gardenia in the night's button-hole—but no! why should a writer never be able to mention the moon without likening her to something else—usually something to which she bears not the slightest resemblance?

Max Beerbohm (1872–1956)
English caricaturist and critic

Every great and original writer, in proportion as he is great and original, must himself create the taste by which he is to be relished.

William Wordsworth (1770–1850)
English poet

. . . novel writing goes, at its best,
beyond cleverness to that point where
one's whole mind and experience and
vision are the novel and the effort to
translate this wholeness into prose is
the life; a circle of creation.

Gore Vidal (b. 1925)
American writer

All writing which is in any way first rate is an effort to tell the truth. Good writing is useful to society because each first rate piece of work adds a little something new to truth. The old truths don't need retelling; first rate writing must always add something to man's knowledge of himself, of man's behavior when he runs in packs, of the world around him.

John Dos Passos (1896–1970)
American writer

Fiction reveals truths that reality obscures.

Jessamyn West (1907–1984)
American writer

Fiction is not fact, but fiction is fact selected and understood, fiction is fact arranged and charged with purpose.

Thomas Wolfe (1900–1938)
American writer

. . . true fiction is always lived from
within and deeply felt.

Rita Mae Brown (b. 1944)
American writer

The pen is the tongue of the mind.

Miguel de Cervantes (1547–1616)
Spanish writer

We must write where we stand; wherever we do stand, there is life; and an imitation of the life we know, however narrow, is our only ground.

John Updike (b. 1932)
American writer

A writer's goal should be to recapture that native, childlike ability to see things in original ways and eschew the "easy stuff" in the process.

James Kisner (b. 1947)
American writer

Often I think writing is a sheer
paring away of oneself leaving always
something thinner, barer, more meager.

F. Scott Fitzgerald (1896–1940)
American writer

I write for myself and strangers.
The strangers, dear readers,
are an afterthought.

Gertrude Stein (1874–1946)
American writer

. . . the writer wrote alone, and the
reader read alone, and they were alone
with each other.

A. S. [Antonia Susan] Byatt (b. 1936)
English writer

Writing, in itself, is like the sound of one hand clapping—incomplete, silent, and without impact. Only when the writer as the one hand, and the reader as the other, confront each other is there that clap, that spark of communication which makes literature alive.

Minfong Ho (b. 1951)
Singaporean journalist and writer

Writers write for themselves and not for their readers and . . . art has nothing to do with communication between person and person, only with communication between different parts of a person's mind.

Rebecca West [Cicely Isabel Fairfield] (1892–1983)
English journalist and writer

My writing . . . is an attempt to re-create my childhood. . . . it's an obsession. . . . for me, it's not a choice, it's a necessity.

Maurice Sendak (b. 1928)
American writer

. . . personal catharsis is a terrible
reason for writing fiction.

Amy Hempel (b. 1951)
American writer

To me, the greatest pleasure of writing
is not what it's about, but the inner
music the words make.

Truman Capote (1924–1984)
American writer

Literature is a tone. It is a melody. If I find the melody of the book, the book is written. . . . It's more than simple rhythm. It's like a musical key, you know you can go on—the book is there.

Eli Wiesel (b. 1928)
Romanian-born American writer

When I write it feels like I'm carving bone. It feels like I'm creating my own face, my own heart—a Nahuatl concept.

Gloria Anzaldúa (b. 1942)
American writer

There are many reasons why novelists write, but they all have one thing in common—a need to create an alternative world.

John Fowles (b. 1926)
English writer

Syllables govern the world.

John Selden (1584–1654)
English jurist

What writing does is allow us to sample each other's fate.

Edna O'Brien (b. 1932)
Irish writer

The universe is made of stories, not of atoms.

Muriel Rukeyser (1913–1980)
American poet

First sentences are doors to worlds.

Ursula Le Guin (b. 1929)
American writer